# MARIO MERZ

# MARIO MERZ

## THE MAGNOLIA TABLE

Exhibition curated by Gian Enzo Sperone

Catalogue essay by Emily Braun

**SPERONE WESTWATER**
415 West 13 Street  New York 10014
212/999-7337 (fax) 999-7338
www.speronewestwater.com

# Mario Merz: Ethnographer of the Everyday

Among Merz's earliest works is an abstracted image of a *Gypsy Wagon* (1953), painted in an expressionist style. Although the artist eventually rejected easel painting for three-dimensional installations, the subject of a wandering caravan is inextricably linked to his later, iconic igloos. They both embody a nomadic, anarchic urge – not one of romantic return to a primordial past, but of an equally romantic resistance against fixity and conditioned ennui. Before they take on the identity of archetypal habitats, from the ur-huts of hunter-gatherers to the mobile encampments of geodesic domes, Merz's igloos are unabashed urban squatters. They impinge upon the structural supports of museum architecture or plop down and dirty in the pristine, white cube of the gallery. Whereas the painting *Gypsy Wagon* could only represent an abstract idea, Merz's igloos, with their contingent physicality, block passage, contest territory, and disturb the environs. Made of miscellaneous materials diverted from their original use and recombined in playful necessity, their fragile structures erected ad hoc by clamping and propping, Merz's installations are monuments to improvisation, eruptive energies, and open-endedness: they are constructions of a happenstance "situation."

Merz's igloos have become the poster child of Arte Povera, a name that has been challenged by the diversity of the artists grouped under its purview and by the seeming opportunism of ethnic labeling in a global market. Nonetheless, "poor art" as a definition of scrappy ingenuity, of creativity born from nothing save ordinary cognitive processes, holds up to scrutiny. The meaning of impoverishment is neither that of humble materials per se, nor of parochial or folkloric themes. It emphasizes everydayness and an economy of means. "We are stripping culture to see what it is made of," to use Merz's words.[1] The ordinary replaces the grandiose, and the artist is re-immersed in the undifferentiated banality of the surrounding environment, in the matrix where culture emerges from nature. The projects of Arte Povera – live theatre, objects, or installations, are consistently performative in their making and reception, demanding of the audience an experiential reciprocity that takes place in real space and over time. Be they indexical traces of organic properties, acts of reiteration and enumeration, bricolage with industrial materials, or expositions of the arbitrary conventions of representation, the works of Arte Povera artists are united by a concerted research into the natural history of the mind.

What can be called the anthropological turn in the making of post-WWII art offered a new model of humanism to replace the shop worn neo-platonic ideals of formal purity and transcendence. In Italy, the return to a common humanity had particular urgency, since the classical tradition associated with high culture had been thoroughly exploited for propaganda purposes under the Fascist regime. Historical consciousness and the desire to define authentic culture through a return to rudimentary making, doing, and

seeing, distinguished Italian artists of the 1960s from their American counterparts. But their investigations "in the field" should not be confused with the euro-centric appropriation of the "other" that characterized early twentieth-century art and modernist primitivism. The generation of Arte Povera artists, coming to age after the Italian economic miracle, turned their attention to a "new humanist" project (to use Germano Celant's terms): disturbing the relentless and seamless flow of media in advanced capitalist society through strategies of sensorial re-enchantment and instrumental actions. Though often linked to the militancy of anti-Vietnam protests, Celant's "Guerilla War," the catchphrase of the movement's initial manifesto, was directed less toward American imperialism in Indochina than to the colonization of Italian "slow" life by the rapidity and cynicism of American consumer culture.

Herein, Arte Povera was directly inspired by the legacy of the Situationist International, whose theoretical precepts gestated for a decade before evolving into the genre of 1960s interventionist art. Influenced by Marxist theories of alienation and Henri Lefebvre's postwar *Critique of everyday life* (1946; 1962), the Situationists theorized the strategies of *détournement* (detours, ruptures) and *dérive* (mobile and swift drifts or ruminations through the urban fabric) that placed the quotidian at the center of a new ethnography – one that researched estrangement from life close-at-hand, rather than intercultural encounters with non-western societies.[2] The Situationists had a strong foothold in Italy beginning in 1955 with the experimental "laboratory" in Alba (outside Turin, home base for Arte Povera) led by Pinot (Giuseppe) Gallizio and joined by the international proponents of the movement, Asger Jorn, Constant, and Guy Debord.[3] The goal was to revivify perceptual awareness of the *durée*, or temporal flow of daily life, to make palpable what had been submerged by an ever more automated and pre-programmed society. Though the Situationists were soon split between political activists and cultural practitioners, their validation of creative resiliency within the everyday shifted the historical avant-garde agenda from one of merging of art and life to the revelation of art *in* life.

Celant's formative declarations and definitions of Arte Povera readily appropriate Situationist themes and strategies, in the spirit of the potlatch, free-distribution of ideas advocated by the earlier movement. His call for "surprise attacks" and the "advantages of mobility," like Merz's *Giap's Igloo* (1968), which inscribes the guerilla maneuvers of the Vietcong general in blue neon, betray the Situationist delight in tactics and ruses, used to reactivate the spaces of existence and challenge institutional authority. Against "rich" forms of art and technology that 'imitate and mediate reality,' the new art will "take possession of realty itself," Celant writes, echoing Debord's theory of the sensorial atrophy engendered by the passive consumption of spectacle. "We are conditioned in such a way that we are

not able to see a floor, a corner or an everyday space." As a form of resistance, the artist will become an active "producer" of "immediately realized sensations," and "elementary situations," embracing the incidental, while avoiding consistency of style and approach. In short, announces Celant, "what has happened is that the commonplace has entered the sphere of art."[4] Not by coincidence, group exhibitions of Arte Povera "artifacts" resemble the heterogeneity, ahistoricity, and didactic displays of ethnographic collections, rather than the conventional installations of fine art museums.

Merz, along with Michelangelo Pistoletto, is the key figure of Arte Povera, and the prime dramaturgist of the covert life of ordinary thoughts and actions. (*Object – hide Yourself!* is a repeated title in his oeuvre.) As the oldest figure in the movement (born in 1925), he provided a generational link between the literate, anti-Fascist circles of Turin and the postwar commodity culture of reconstruction. Around 1960, Merz had direct contact with Pinot-Gallizio, a pharmacist, and amateur archeologist and ethnographer, who was by then active in Turin art circles. Merz's persona as the artist-clochard was undoubtedly influenced by Situationist "research" into the annual gypsy encampment in Alba, and Constant's *Model for a Gypsy Camp* (1956-1958) designed as a spherical shelter with interior movable partitions. Implementing the nomadic into the making of art itself, Pinot Gallizio began to produce his "industrial painting" – oil blithely flung on kilometers of canvas rolled out and cut to order, to be hung up anywhere, perpetually mobile. As Pistoletto recounts it, Merz's engagement with Gallizio, whose "grotto" installations crossed the line into happenings, led to his eventual abandonment of easel painting. He arrived to install his 1962 solo show at Galleria Notizie with a single painting, structurally unsound, consisting of layer upon layer of accumulated paint – the vertical equivalent of Gallizio's horizontal extensions.[5] Gallizio died in 1964 never fully abandoning the expressionist Cobra-group imagery of Jorn and Karl Appel. By 1966 Merz had initiated his career as "one very long Sunday," metaphorically refuting the social structures of regulated work and, in practice, jettisoning the artistic labor of mimesis for the handy "products of other men."

Merz's self-conscious identification with the gainfully unemployed ethnographer of everyday life, evident in his vagabondage themes, spilled over into his actual living habits. Gian Enzo Sperone recalls that Merz was indifferent to property and material comforts (save for wine) and for years shifted from one barely furnished apartment to another. His traffic with the everyday emerged in his very first Arte Povera works of 1966-7 that present wicker baskets, glasses, bottles, roasting pans, and other containers that we hold and carry as a matter of daily course. No longer the anti-aesthetic gesture of Duchamp's readymade, Merz's isolation of objects gives rise to the pleasures of basic sensuous perception (hence, returning to the fundamental ground of aesthetics). They force viewers into a phenomenological encounter

with the surfaces, edges, spaces, shapes, volumes and textures that are normally overlooked when in "use." The neon tubes redirect the mind to previously discounted minutiae, bestowing upon the mundane the brilliant light of psychical flow. Referred to by the artist as "transfers of energy," the bolts of light literally embody Husserl's ego beam, the rays of mental attentiveness, and the shine of immanence. Merz subsequently used neon to form words and numbers, making consciousness manifest in the acts of naming and counting. As in the essentialist *Senza titolo* (1971), the Fibonacci formula of numeric progression is simply a system of ordering, measurement and the demarcation of space before it takes on the symbolism of organic and cultural accretion.

Merz's predilection for these specific household objects valorizes another commonplace – the rituals of the domestic sphere. In the seminal piece, *Mario Merz's Kitchen: Fibonacci Series from 1 to 5* (1968) neon numbers placed at incremental intervals inject play and perceptual acuity into the *seemingly* most inconsequential workaday routine. The presence of numbers redoubles the mental calculations involved in the buying, preparation, and consumption of food, a theme he soon expanded in the series of actually laden and proliferating tables. Merz's overturning of social hierarchy and status highlights the subversive feminist element in the revelation of the everyday. Less valued in our society because of their low economic re-numeration, habitual kitchen tasks, as with vanishing artisan labor or agriculture, arguably remain closer to real lived experience. Significantly, Merz partnered with Marisa Merz, the only woman artist in the Arte povera movement, whose own projects address the proliferation of human numbers and, hence, the anonymous work of women involved in raising children and keeping house.

For the Situationists, the street was the other privileged site of the everyday, and Merz's work seizes upon the energies gathered and dispersed (Giap's observations) on the city pavements. Alongside the kitchen objects, he produced his signature raincoats and umbrella – those personal items we take with us when we leave the private for the public sphere. Anything but pristine examples of consumer goods (Steinbach's or Koons' fetishistic objects of desire), the worn and strewn artifacts bear witness to the idle intrepidness of the urban drift. Utilitarian objects of protection and cover, yes, but the umbrella and raincoat also refer to the iconic accoutrements of the Parisian boulevardier memorialized in Impressionist paintings of the modern metropolis. Like the flâneur's roving eye, the neon tubes pierce through surface appearances, physical embodiments of the trajectory of empirical cognition. In a further nod to Situationist theories of *détournement*, the neon words scrawled over Merz's installations are recognizable as anonymous graffiti, before they are read for content or taken for anything else. Graffiti ruptures the boundaries of social control, asserts the voice of

the irrepressible, physically marks the presence of the self in the anonymous mass, and encroaches upon space and property. His act of illuminating famous revolutionary slogans in the upstart calligraphy of the street, underlines the historical link between the Situationists' disruptive strategies and the student unrests of 1968. (In fact, the names of two of his pieces, *solitaire solidaire* and *objet cache-toi*, were taken from writing on the wall in Paris in May 1968.[6])

In the history of postwar European art, Merz is often compared to Joseph Beuys. They share generational positions and come from the defeated nations in the war (though Merz was an anti-Fascist and imprisoned for his partisan activities). Their work mixes industrial and organic materials, imparts a reverence for nature, and both produce sculptures as conduits of communal interaction. But to perceive Merz as a shaman misconstrues the artist and his work: he did not appear as the central actor in live performances, nor did he take on the role of the healer of historical trauma, as did Beuys. The apparent ritual and nature mysticism in his art are the consequence of his procedures – revealing underlying structures of human activities – rather than a metaphysical narrative of redemption. Whereas Beuys privileges the use of honey as a symbolic nutrient and salve, Merz chooses to work with a different material of the hive – the wax produced in cellular structures by the social formations of the worker bees. The presence in his work of wax (one of the earliest materials used by man for modeling and casting), as well as welded metal, stacks of newspapers and neon tubes (produced by a skilled worker) incorporate a progression from primitive to advanced technologies, and attest to his larger thematic concern with temporal continuum and the resulting proliferation of materials, forms, and concepts. Progress cannot be denied or reversed, but awareness of the synchronic overlays amidst diachronic development can be enhanced, reconnecting one to the growth cycles of nature and their correlate, human rituals.

Merz's displays of natural and cultural accretion found direct inspiration in the ideas of Claude Lévi-Strauss, whose books on structural anthropology were published in Italy in the 1960s. (Being fluent in French and part of the Situationist orbit, Merz may well have read him years earlier.) In *The Savage Mind* (or way of thinking) Lévi-Strauss defined the "concrete science" of "primitive" as the propensity for order, classification, and differentiation: "the universe is an object of thought as much as it is a means of satisfying needs."[7] The human mind is constantly engaged in perceiving structures and hence, creating forms and sign systems out of sensory data. As in Arte Povera projects, the merely instrumental – bundling, stacking, aligning, counting – becomes the fertile ground of sensorial play and pleasure, bracketing off our consciousness from the undifferentiated flow of time. In a passage that points to Merz's inclusion of real fruits of the earth in installations such as *Tavola a spirale* (1982) Lévi-Strauss maintains*:*

> Any classification is superior to chaos and even a classification at the level of sensible properties is a step towards rational ordering. It is legitimate, in classifying fruits into relatively heavy and relatively light, to begin by separating the apples from the pears even though shape, color and taste are unconnected with weight and volume. This is because the larger apples are easier to distinguish from the smaller if the apples are not still mixed with fruit of different features. This example shows that classification has its advantages even at the level of aesthetic perception.[8]

The Fibonacci series is one of the leitmotifs of Merz's oeuvre because it provides a conceptual system that links the present and the past, the empirical and the symbolic. "Nature is the art of the number," the artist affirms. Identified by an Italian mathematician in the early thirteenth century, the Fibonacci formula of numerical expansion adds the preceding two digits to make the next in the sequence (1, 1, 2, 3, 5, 8, 13…) As an indexical system of measure, Merz's neon numbers traverse walls and piles of objects to make visible increasing intervals of space and time. It finds organic analogies in the incremental growth of shells, pinecones and animal horns – all reoccurring motifs in the artist's personal iconography. It also begets the synoptic images of the winding spiral and projecting cone; as signs for movement, the former circles back in on itself, the latter propels forward. In addition, the Fibonacci system find analogies in Lévi-Strauss' structural model of myth, bequeathing a given set of parameters (or narratives) that link it to previous iterations, but open to elaboration and transformations wrought by historical time.

*Pianissimo*, a magisterial work of 1984 collects symbols of growth and duration as a cabinet of curiosities, whose panels are formed by the shapes of leaves torch cut by a New York machinist. At first glance, it resembles Giacometti's caged sculpture of biomorphic forms engaged in brutal sexual conflict, but Merz presents a far more gentle narrative of productive symbiosis. The title means very slowly and very softly, evoking to the temporal and material properties of beeswax, and the larger melding of organic processes into complex social structures. The transformation of nature into culture is embodied in Lévi-Strauss' concept of the "raw" and the "cooked,"[9] which is directly evoked by Merz in the aluminum cooking pan filled with the product of the hive (another commonly found object in his oeuvre). The pine cone represents biological generation, while the cone-shaped lance, a weapon used in the human conquest of nature, directs our attention toward diachronic progression, or what the artist calls "the vanishing point of time."

Structural anthropology and ethnography of the everyday come together in the conviction that the roots of creativity lie in the scrutiny of the immediate environs and the exigencies of daily life. For Lévi-Strauss, as for Lefebvre, necessity is the mother of invention. Merz's structures – the igloo and the table – are truly primary because they deal with the needs of shelter and sustenance. Like the nomadic hut, a table is a mobile object, but it also sets down the roots of eating and sociability detailed in Lévi-Strauss' writings on culinary rituals. In Merz's installations, tables accrue in Fibonacci increments or expand in spiral plentitude. In the case of *Quattro tavole in forma di foglie di magnolia* (1985) Merz lays out a repast of bricolage, an ad hoc assemblage of things and signifiers. Made of modeled beeswax and welded steel, the leaves of the table are simultaneously the leaves of a tree. They can unfold inward or outward, with the potential to increase in units and with people, in a playful multiplication or "tabling" of numbers (the *tavola pitagorica* in Italian). Embedded across the surface are elemental materials of creation: colored pigments; charcoal sticks in the shape of a tree, whence they came; and small iron burners —the fire that melts the wax and the metal. The cone, plant, and accordian file add to the layered symbolism of natural and cultural proliferation. As Lévi-Strauss notes, the bricoleur draws from a pre-existing repertoire of objects and ideas; he is restricted by existing terms, but able to expand meaning and function by virtue of new combinations. Even at its most literal, or *povera*, Merz's art generates a plentitude of historical references and symbolic associations.

Hence the *Tavola a spirale* is also the spiral horn of plenty, for the true abundance provided by Merz's work occurs in its cyclical harvest of creativity: during the duration of each installation and every time it is reincarnated in another site and context, one must buy new fruits and vegetables. Now that the artist is deceased, the tasks of marketing and arrangement have been bequeathed, and the table's social function extended in time. How to make a work of art? One must discern and classify number, weight, form, and color; peruse the leafy and fleshy, the pyramidal and round – perhaps even the raw and the cooked. And then to group and lay them out: a single precious line of bell peppers like an Edward Weston photograph or squash and root vegetables heaped in Archimboldo excess? In the "open work" of art, we are made cognizant of the various possibilities within a given parameter, of diachronic extension and synchronic layering. Merz succeeds in objectifying our subjective responses to the everyday, from pragmatic choice to cultural referent. He has turned our attention to the wonderment of ordinary things that we have never seen or richly experienced before.

Emily Braun, New York, October 2007

[1] Mario Merz, "Una domenica lunghissima dura approssimativamente dal 1966 e ora siamo al 1976" ("A very long Sunday…,") in Merz, *Voglio fare subito un libro*, ed. Beatrice Merz, Frankfurt, 1985, pp. 94-98; this volume of collected writings is the source for the other statements by the artist cited herein.

[2] On the role of the quotidian in post-war thought and the counter-culture see Michael Sheringham, *Everyday Life: Theories and Practices from Surrealism to the Present*. Oxford, 2006. See also Henri Lefebvre, *Critique of Everyday Life*, vol. II, *Foundations for a Sociology of the Everyday*, trans John Moore, London, 2006, and Simon Sadler, *The Situationist City*, Cambridge Mass., 1999.

[3] The Situationist movement was formed in 1957 out of a temporary alliance between Guy Debord's Lettrist International (founded 1952) and Asger Jorn's International Movement for an Imaginist Bauhaus (founded 1953). In 1956 Jorn and Pinot Gallizio met in Italy, leading to their collaboration in the "Primo Laboratorio di Esperienze Immaginiste," which was located in Gallizio's house in Alba. For a detailed history of the Imaginist Bauhaus and the Situationist group in Italy including reprints of archival documentsee Mirella Bandini, *L'estetico il politico: da Cobra all'Internazionale situazionista 1948-1957*, Rome, 1977 .

[4] See the movement's foundational texts by Germano Celant "Arte Povera: Notes for a Guerilla War," *Flash Art*, 5, November-December, 1967; "Arte Povera-Im spazio," La bertesca/Masnata/Trentalance, Genoa, 1967; "Arte Povera" De' Foscherari Gallery, Bologna, 1968, all translated and reprinted in Carolyn Christov-Bakargiev, *Arte Povera*, London, 1999, pp. 194-95; 220-221; and 222-224.

[5] See the personal recollections in "Mario Merz e Michelangelo Pistoletto: il significato di Gallizio per la nuova generazione," in Mirella Bandini, *Pinto Gallizio e il Laboratorio Sperimentale d'Alba del Movimento Internazionale per una Bauhaus Immaginista (1955-57) e dell'Internazionale Situazionista (1957-60,* Turin, Galleria Civica d'Arte Moderna, pp. 27-29.

[6] Germano Celant, ed., *Mario Merz*, New York, Solomon R. Guggenheim Museum and Electa, 1989, p. 106

[7] Claude Lévi-Strauss, *The Savage Mind* (1962), Chicago, 1966, p. 3.

[8] Ibid. p. 15

[9] Lévi-Strauss, *The Raw and the Cooked: Introduction to a Science of Mythology* (1964), trans by John and Doreen Weightman, New York, 1969.

Plates

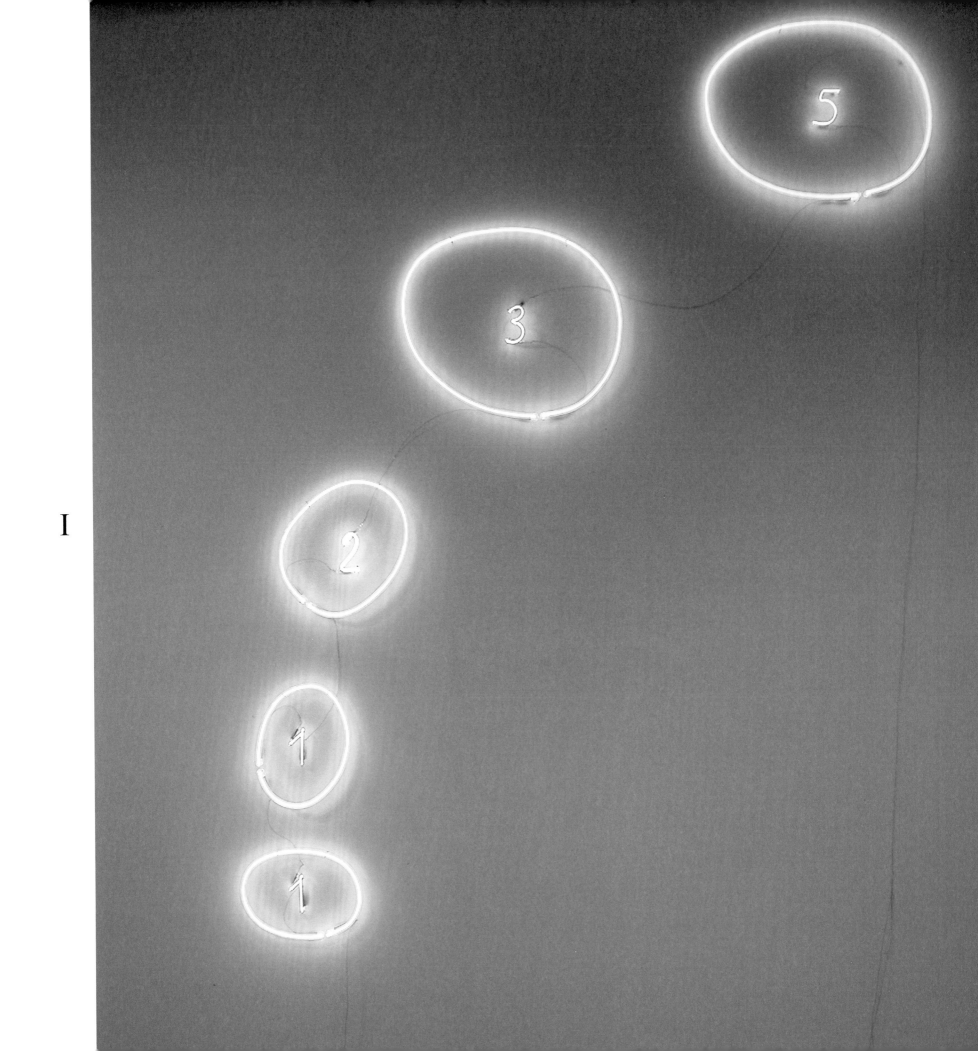

I

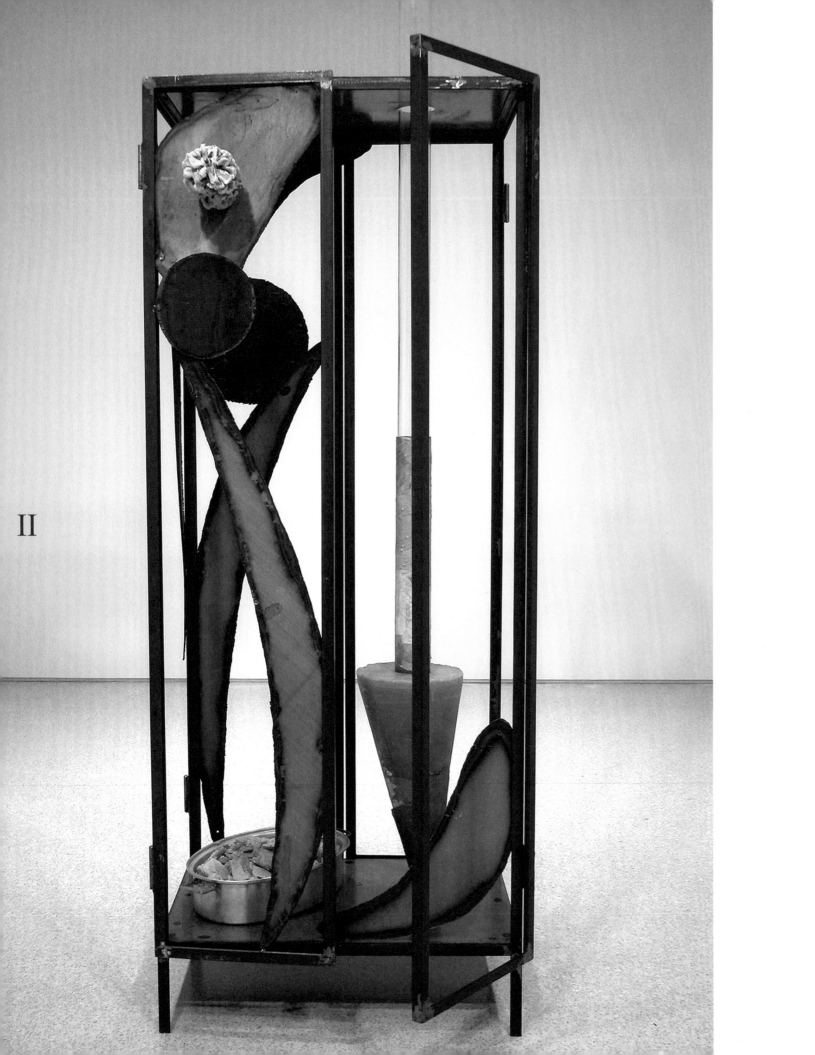

II

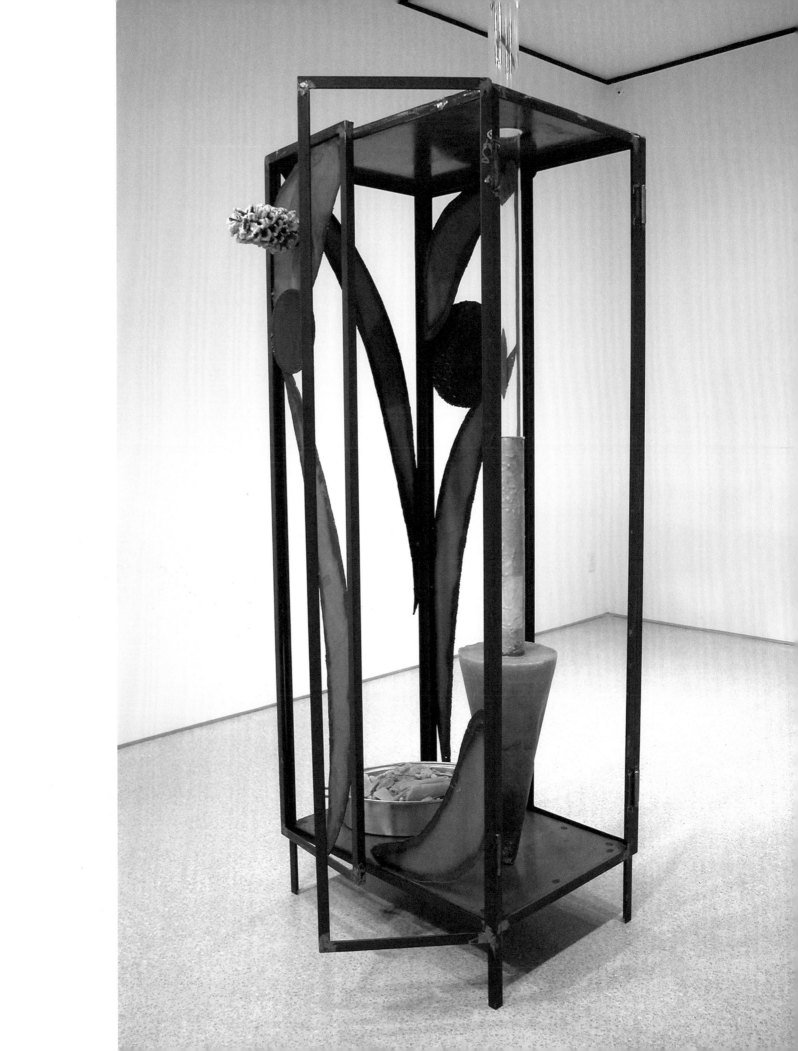

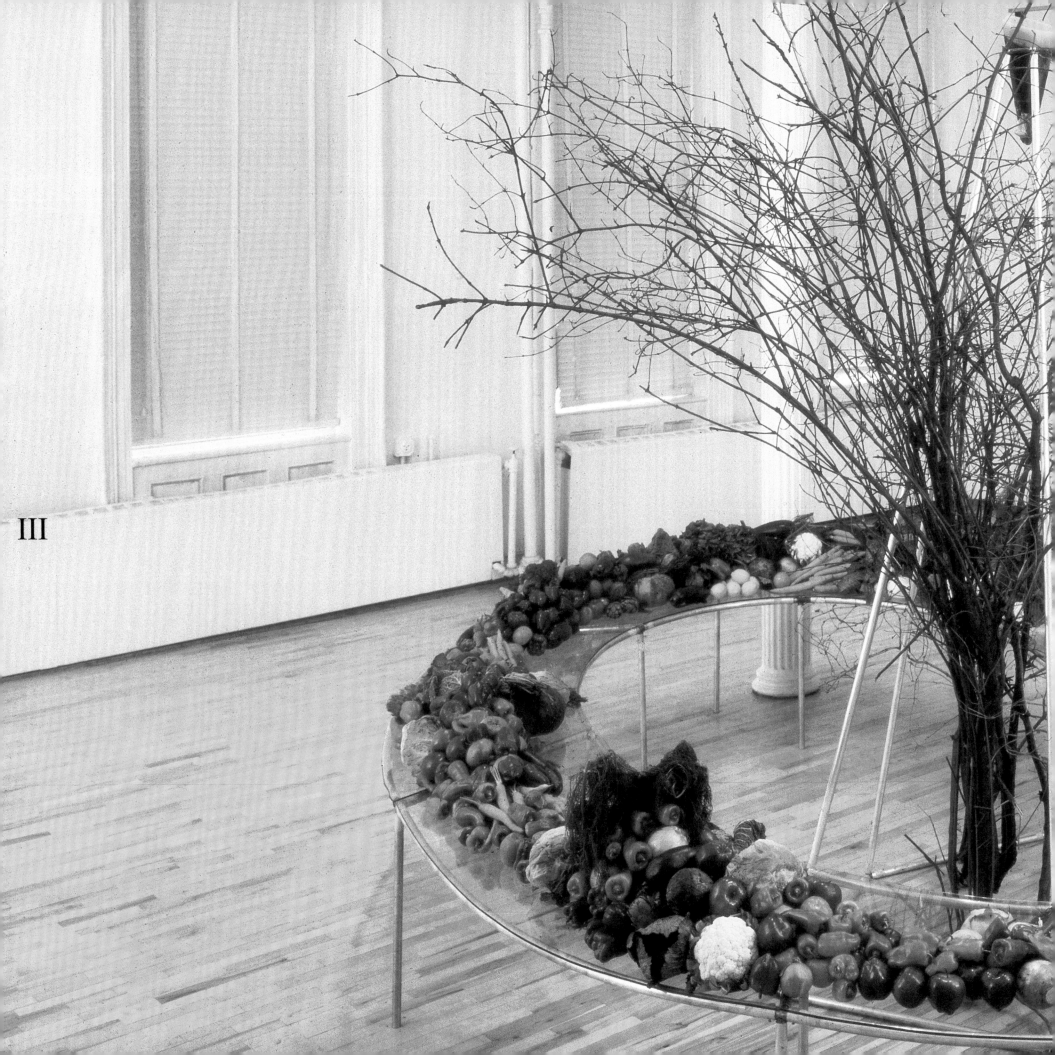

III

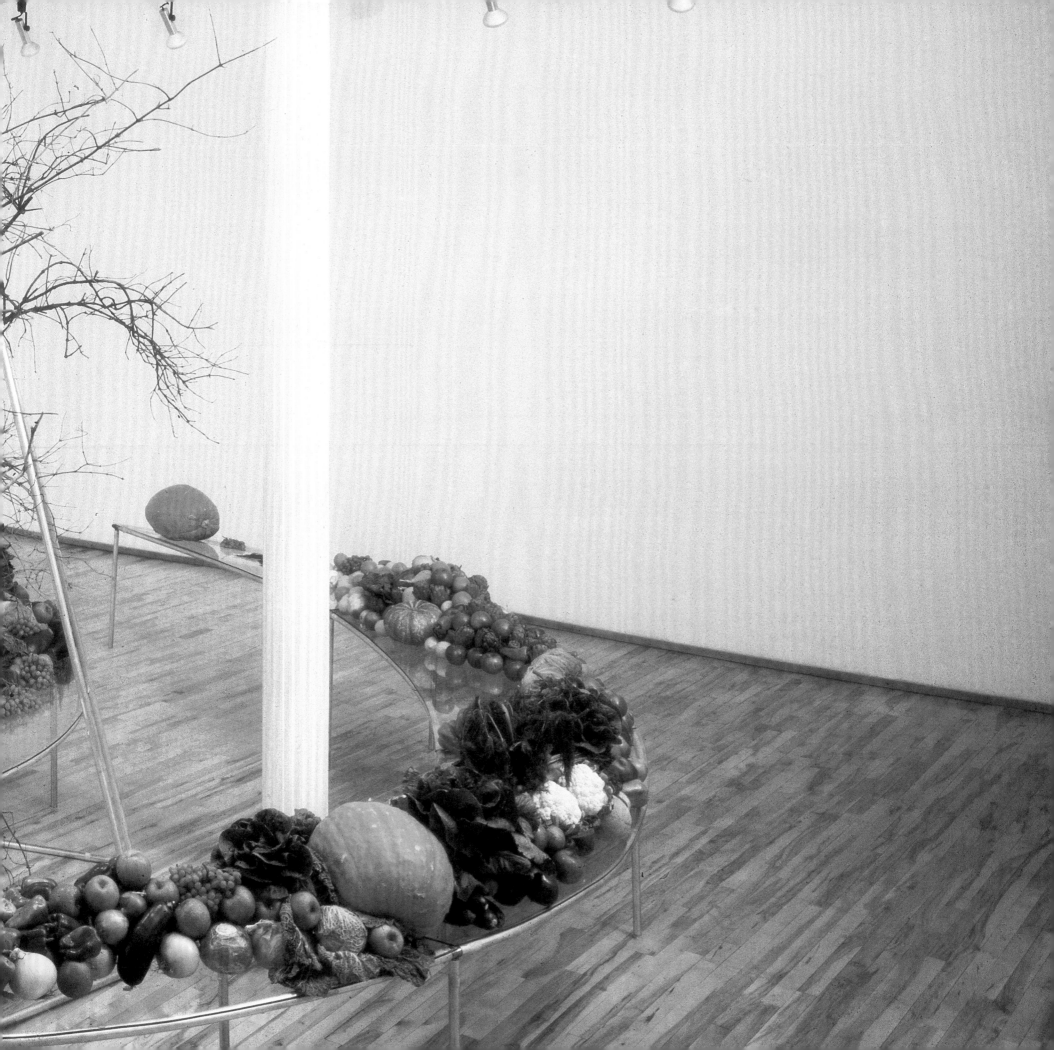

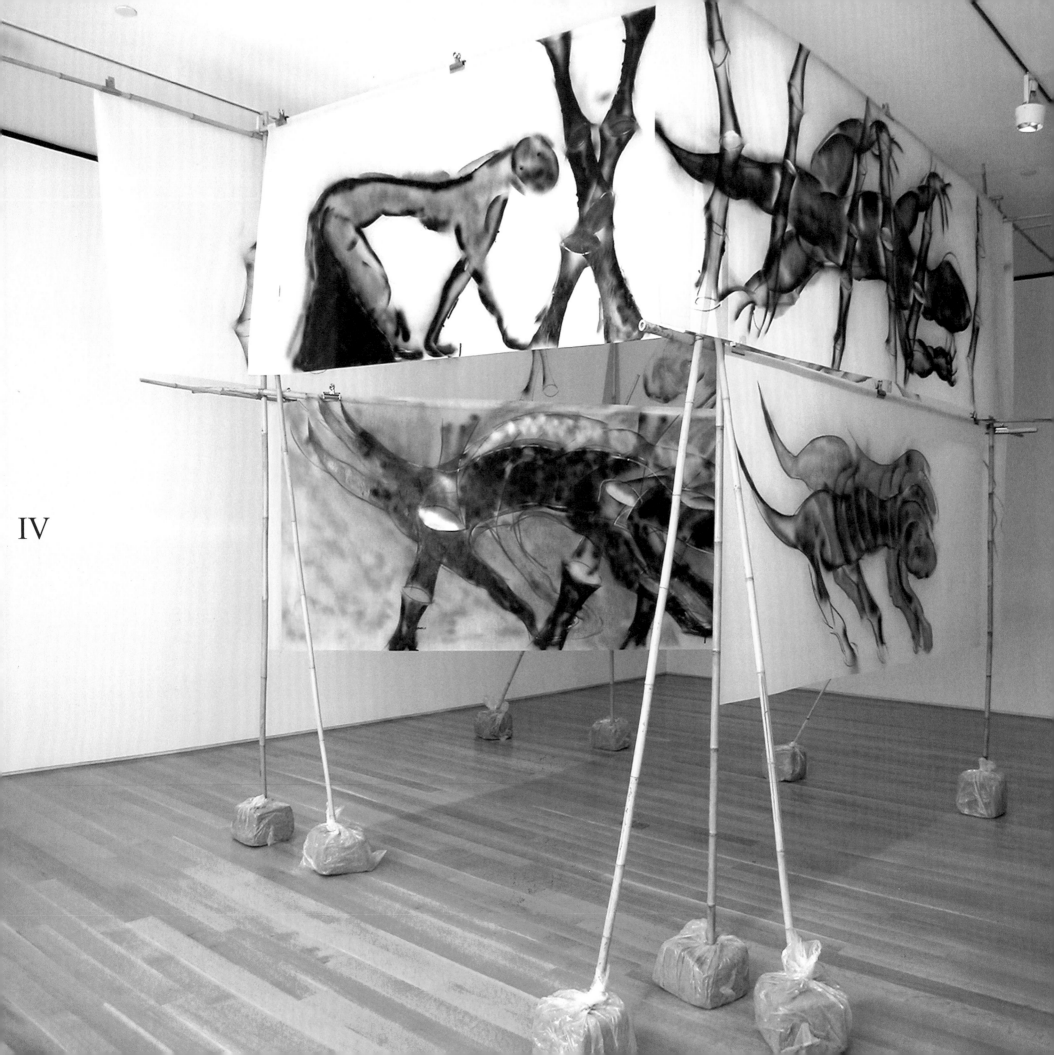

IV

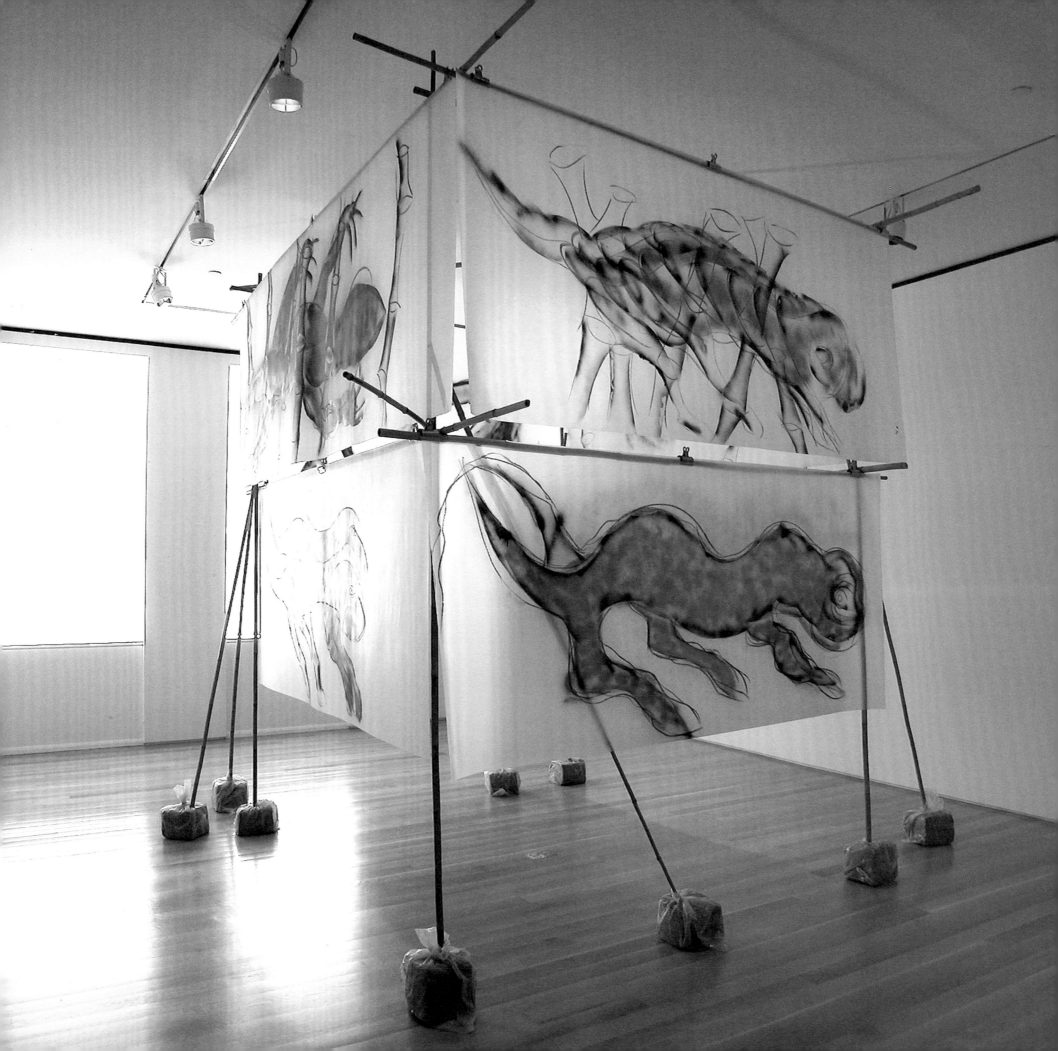

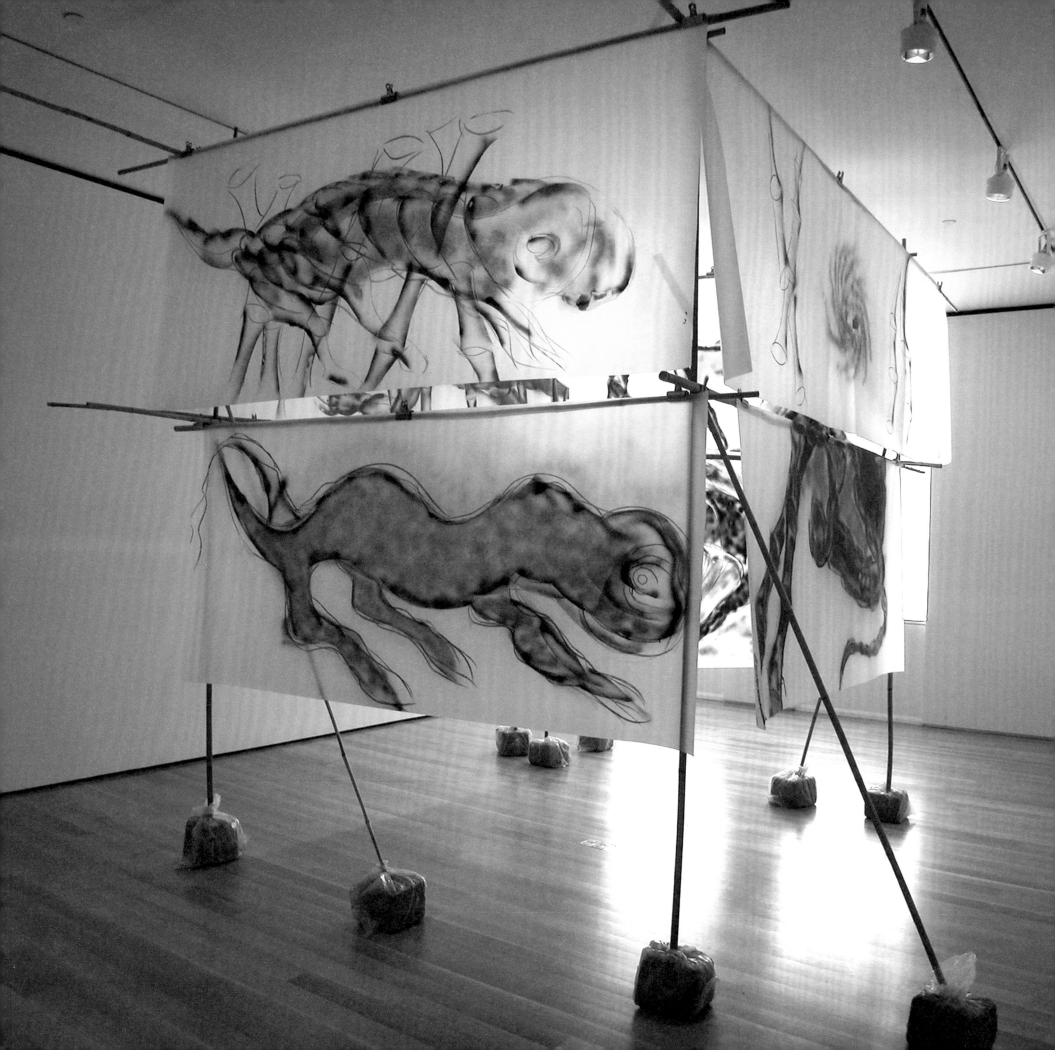

V

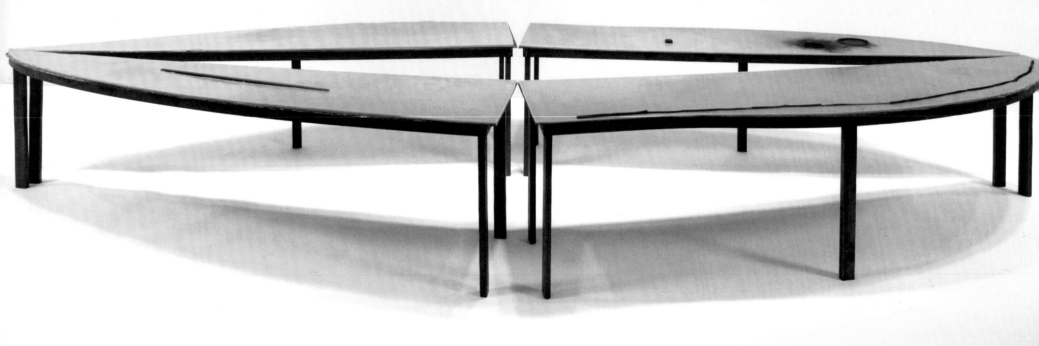

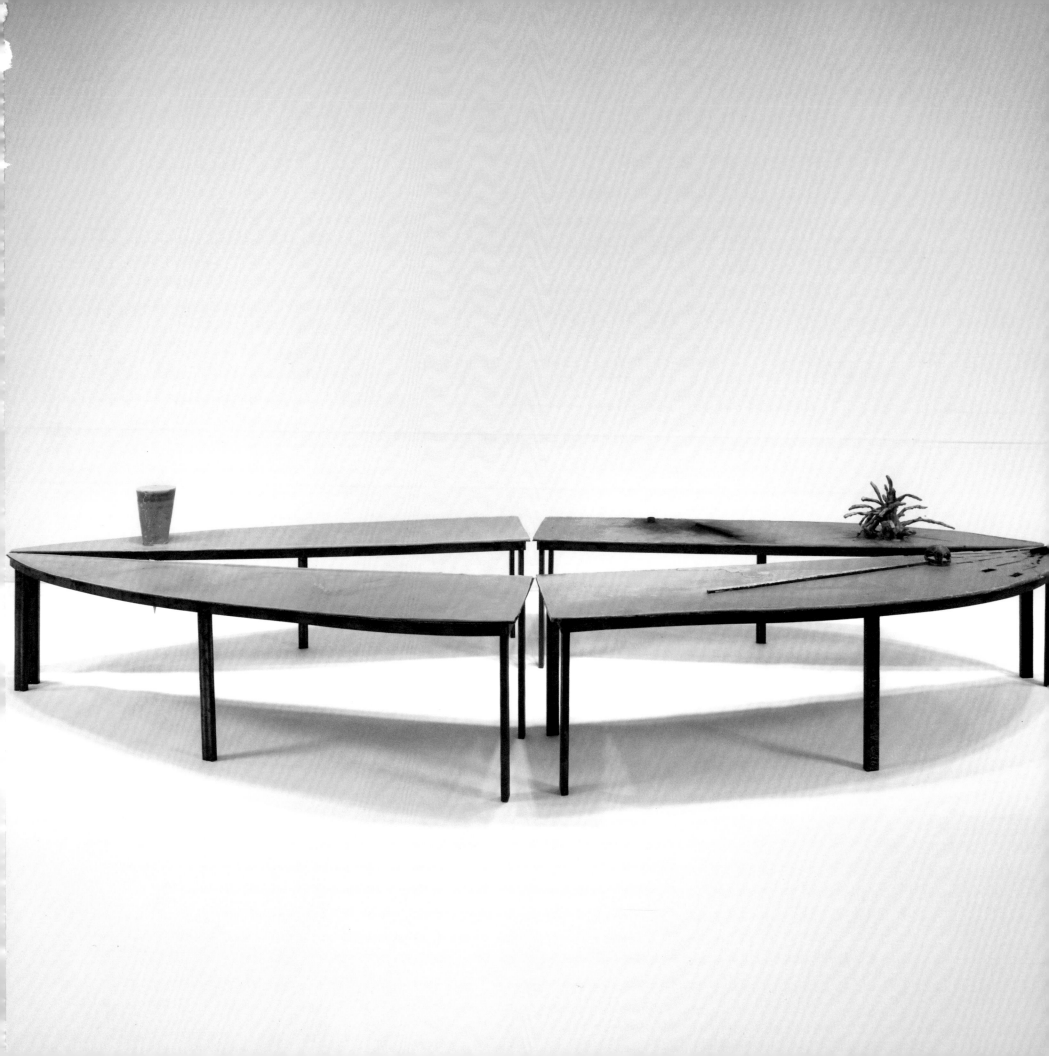

Quattro tavole in forma di foglie di magnolia

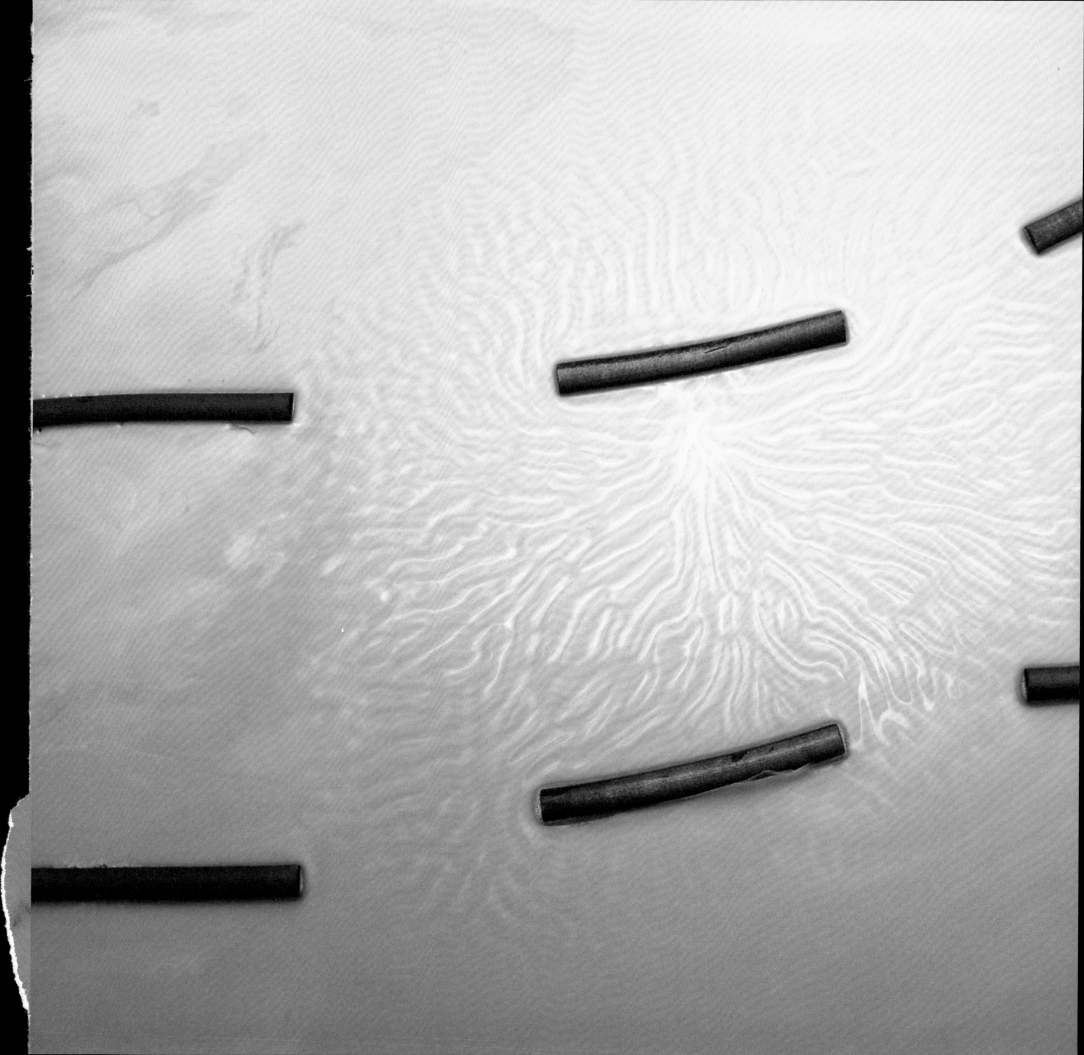

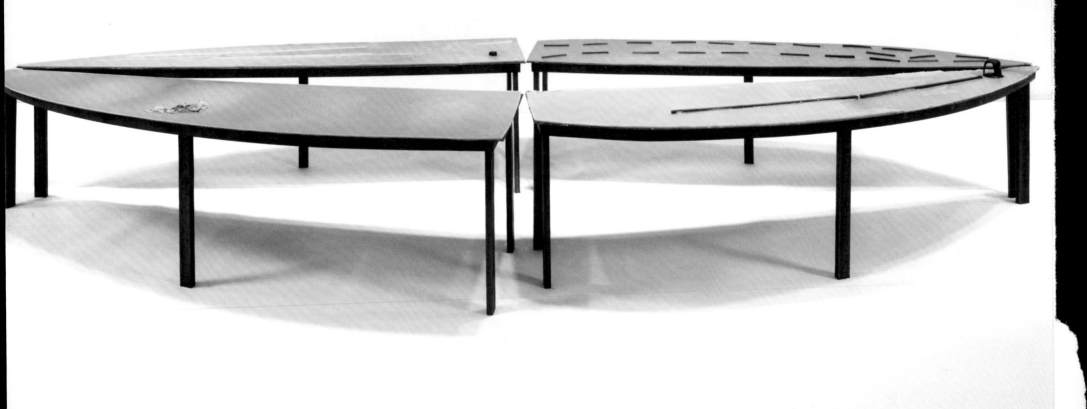

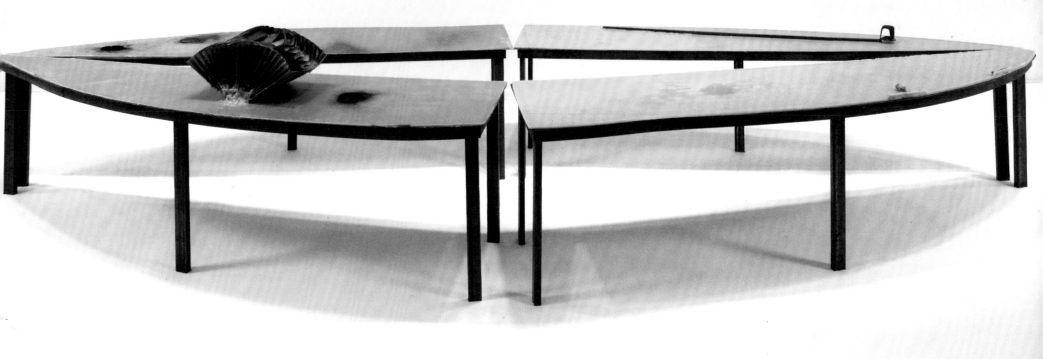

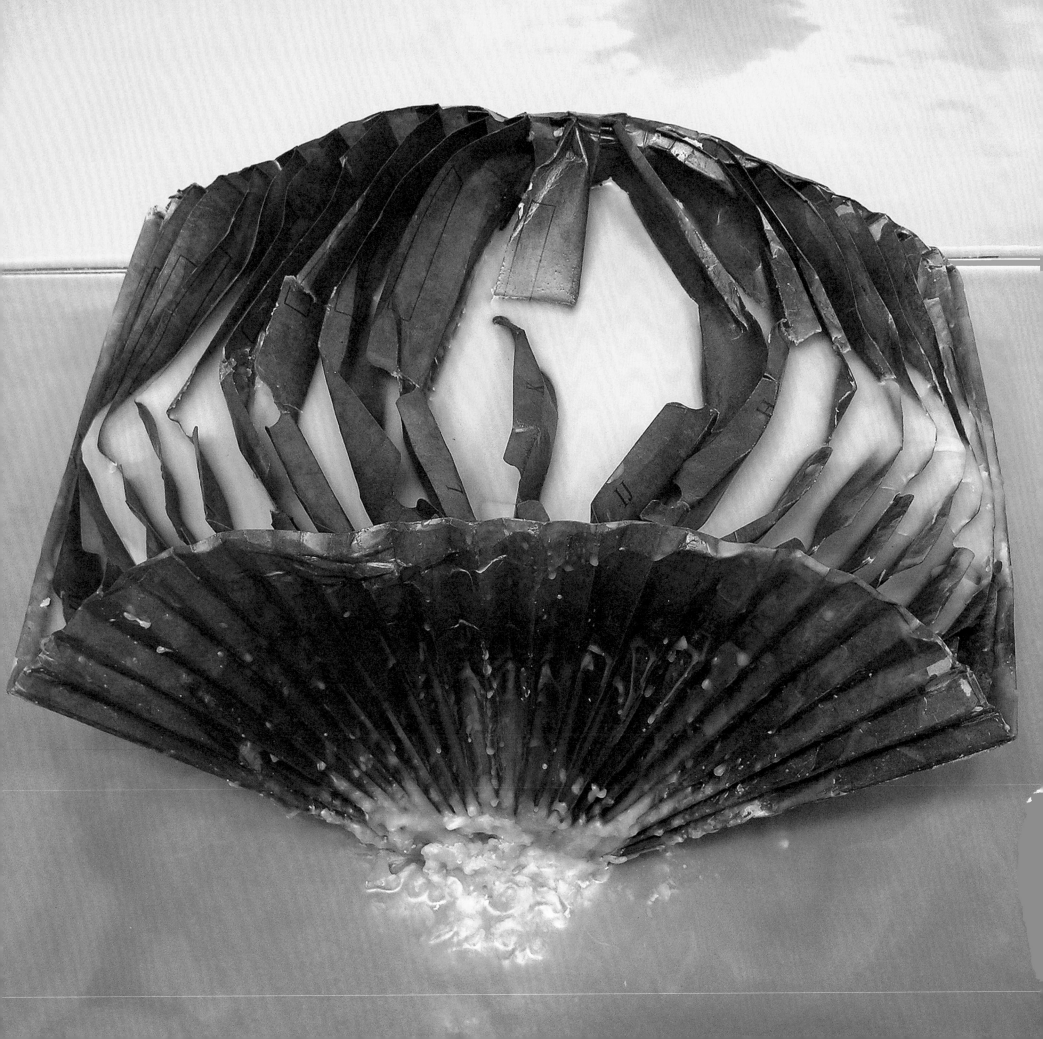

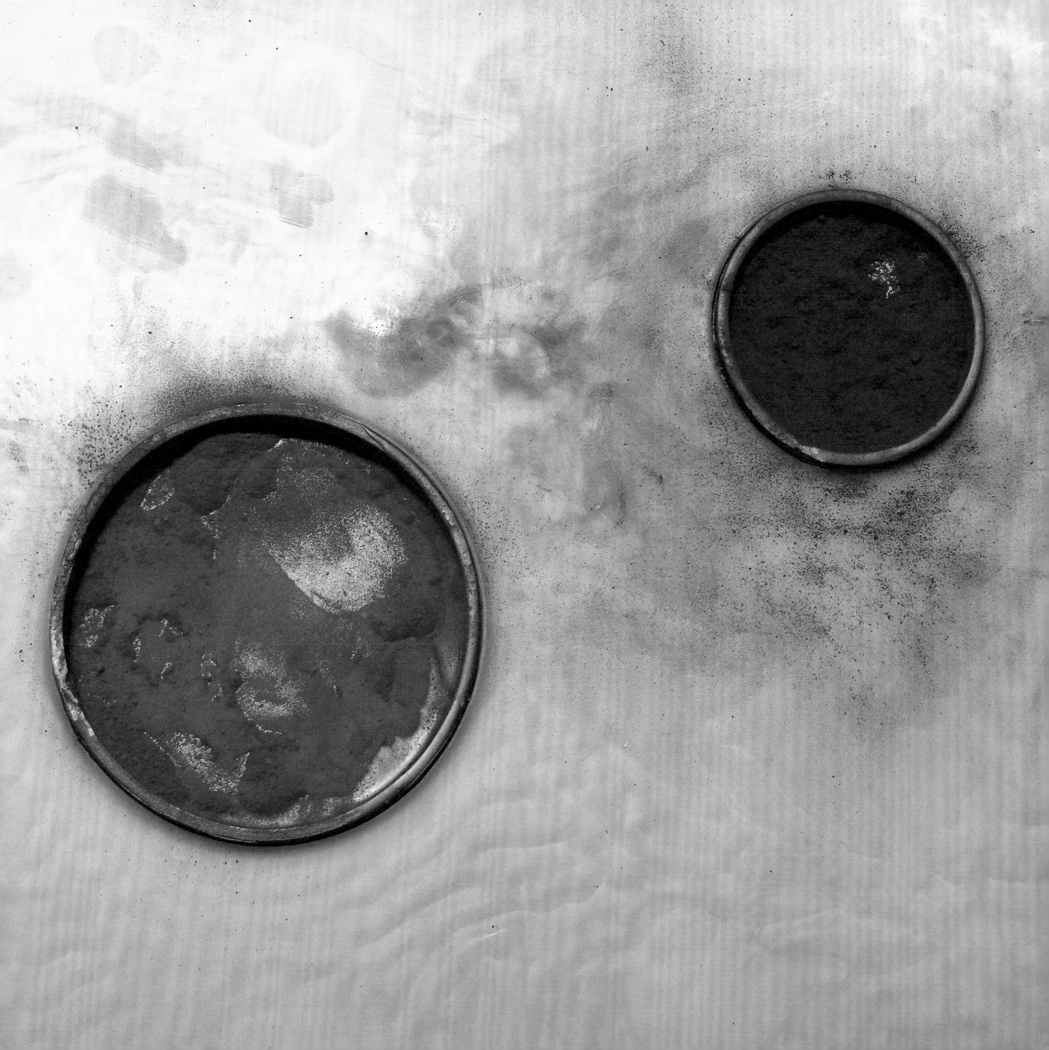

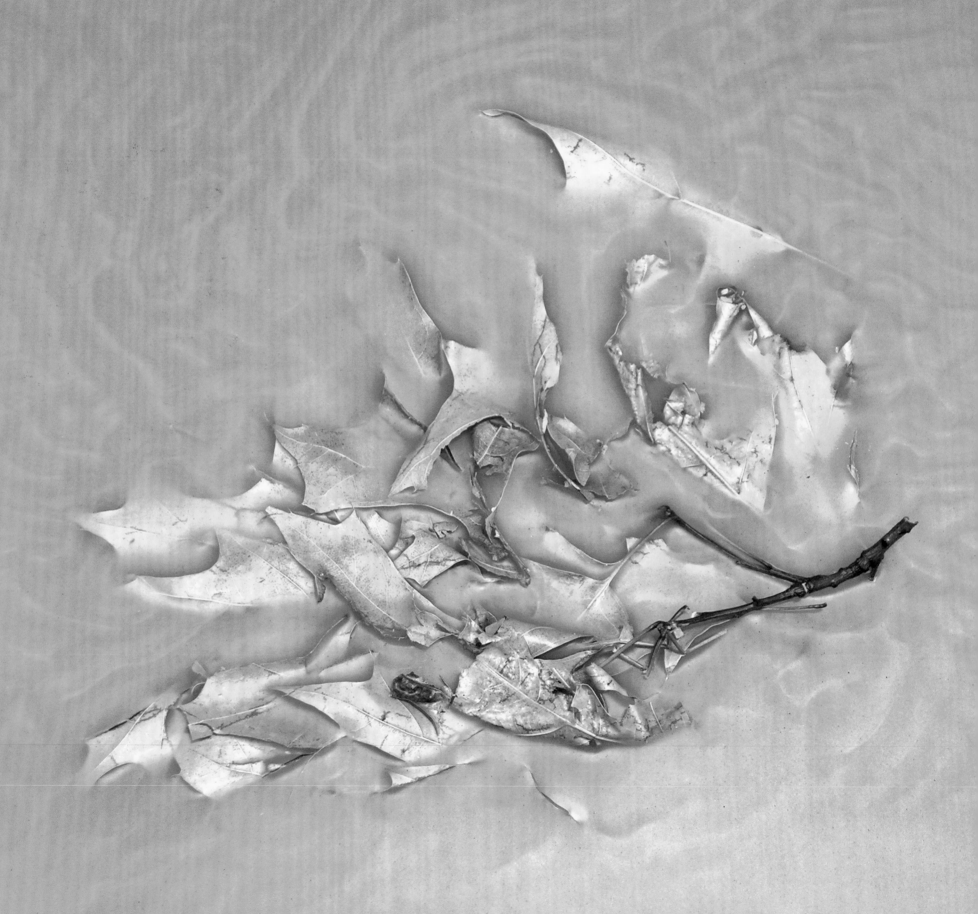

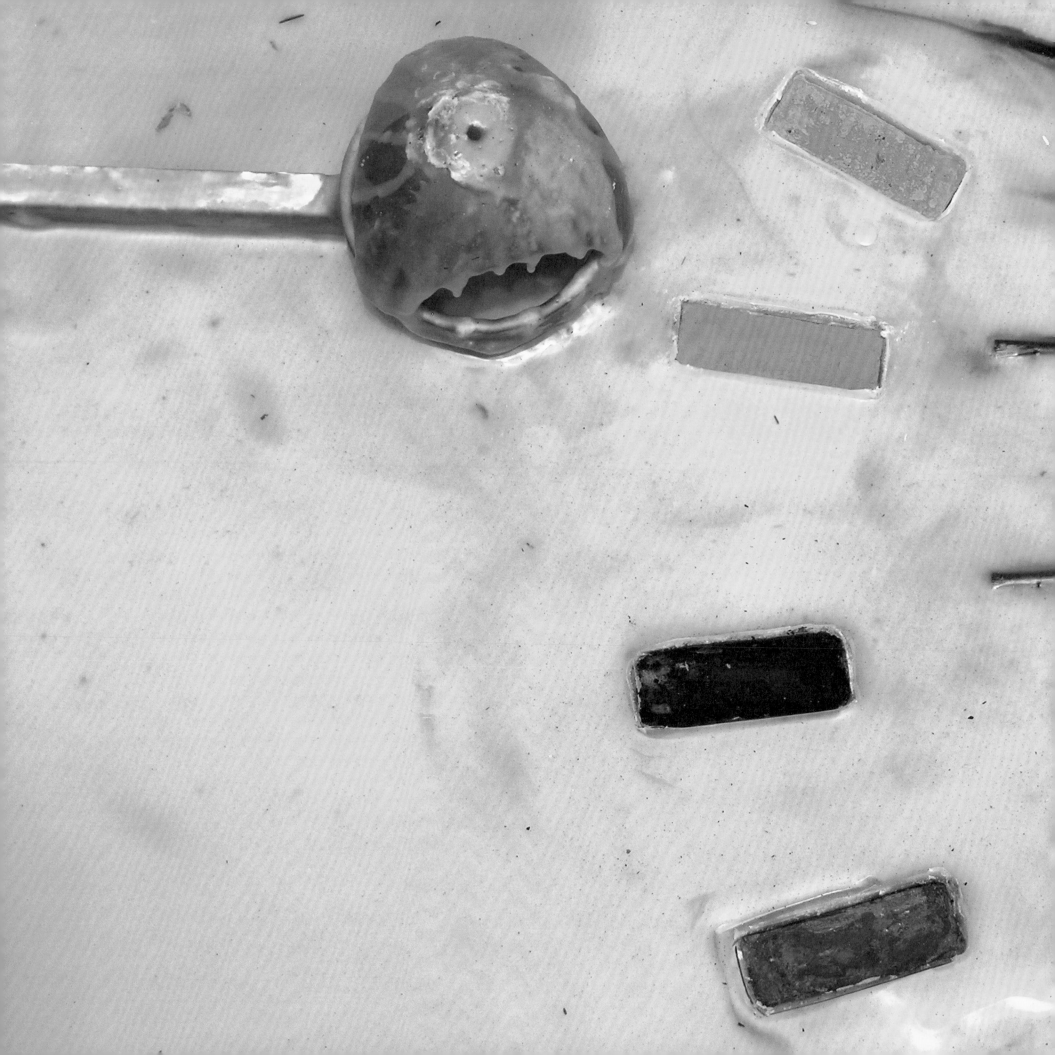

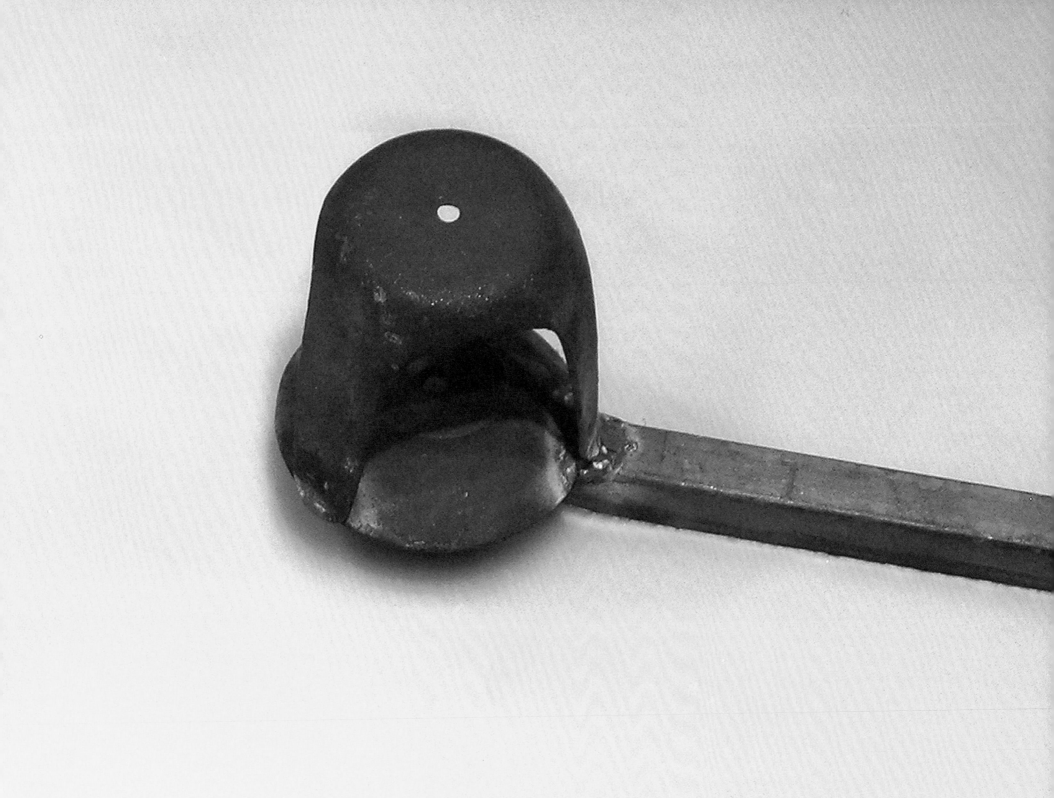

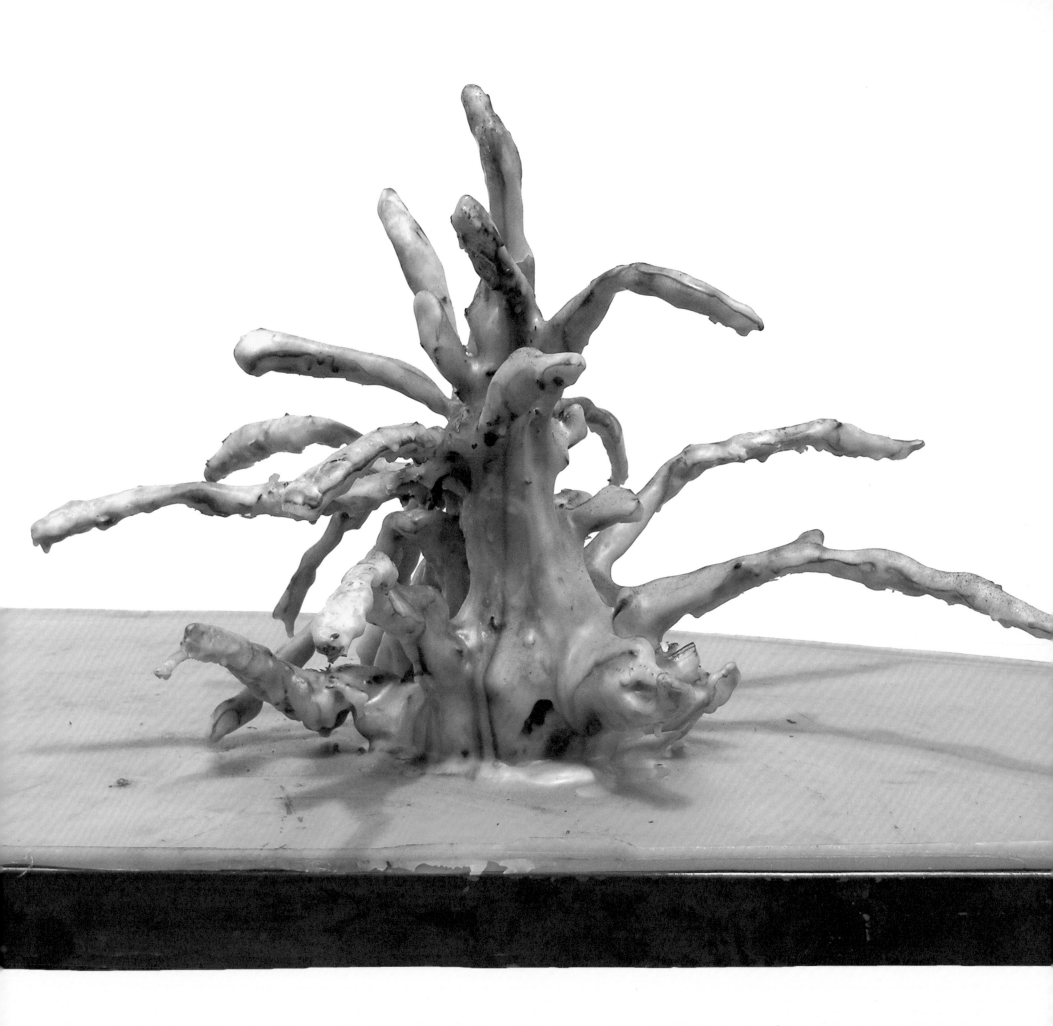

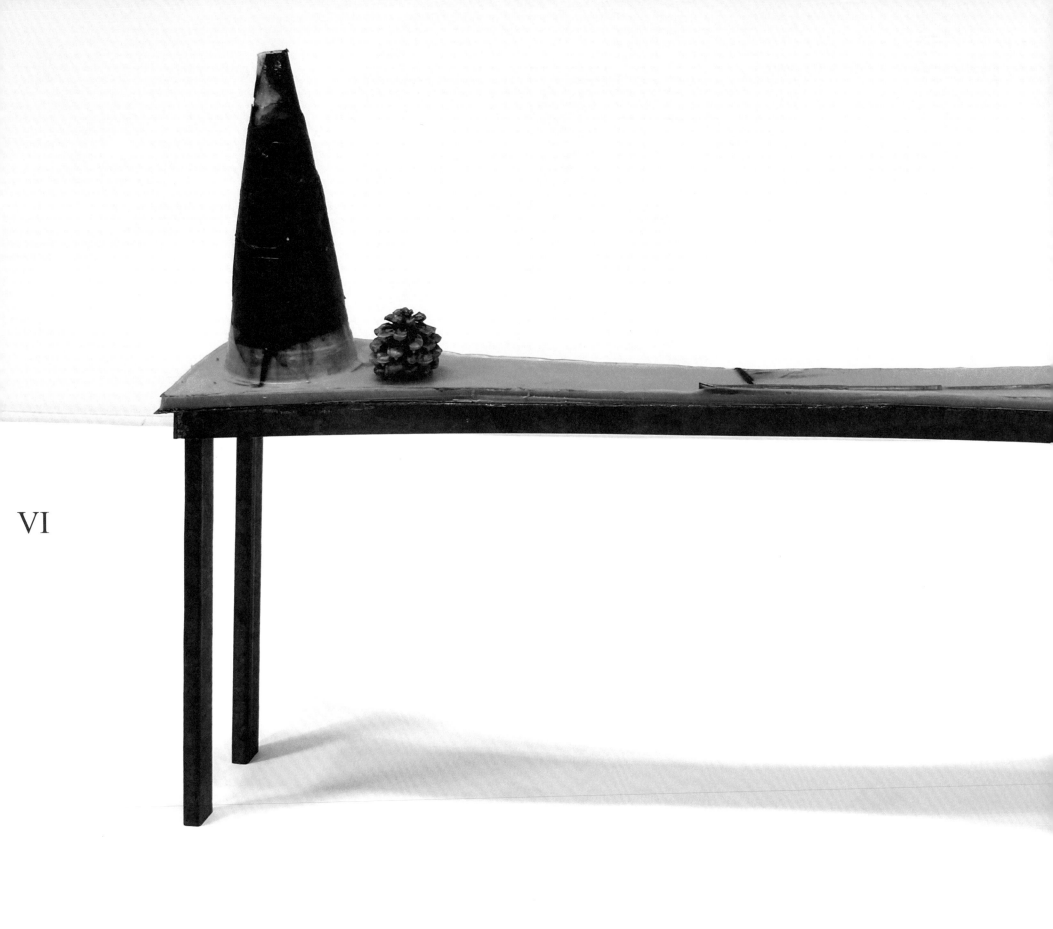

VI

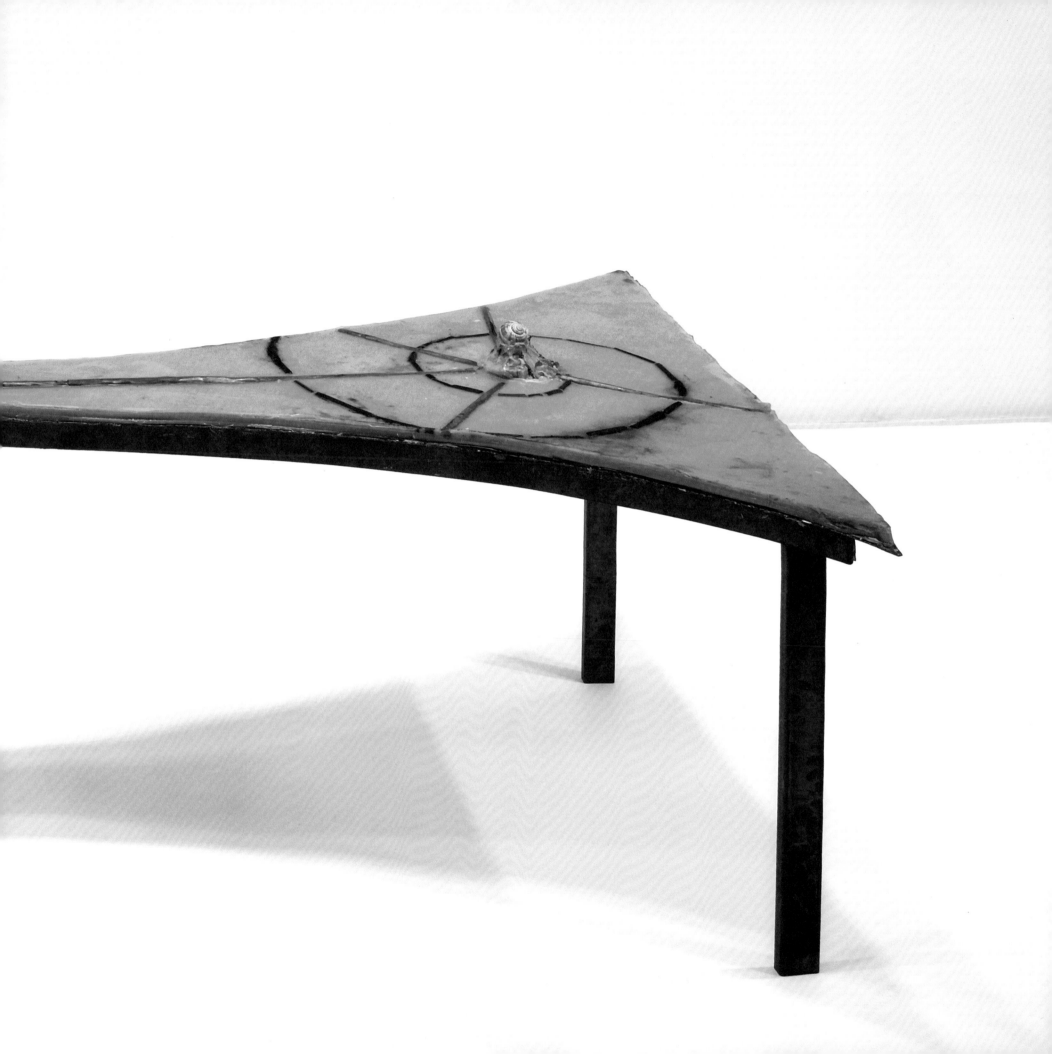

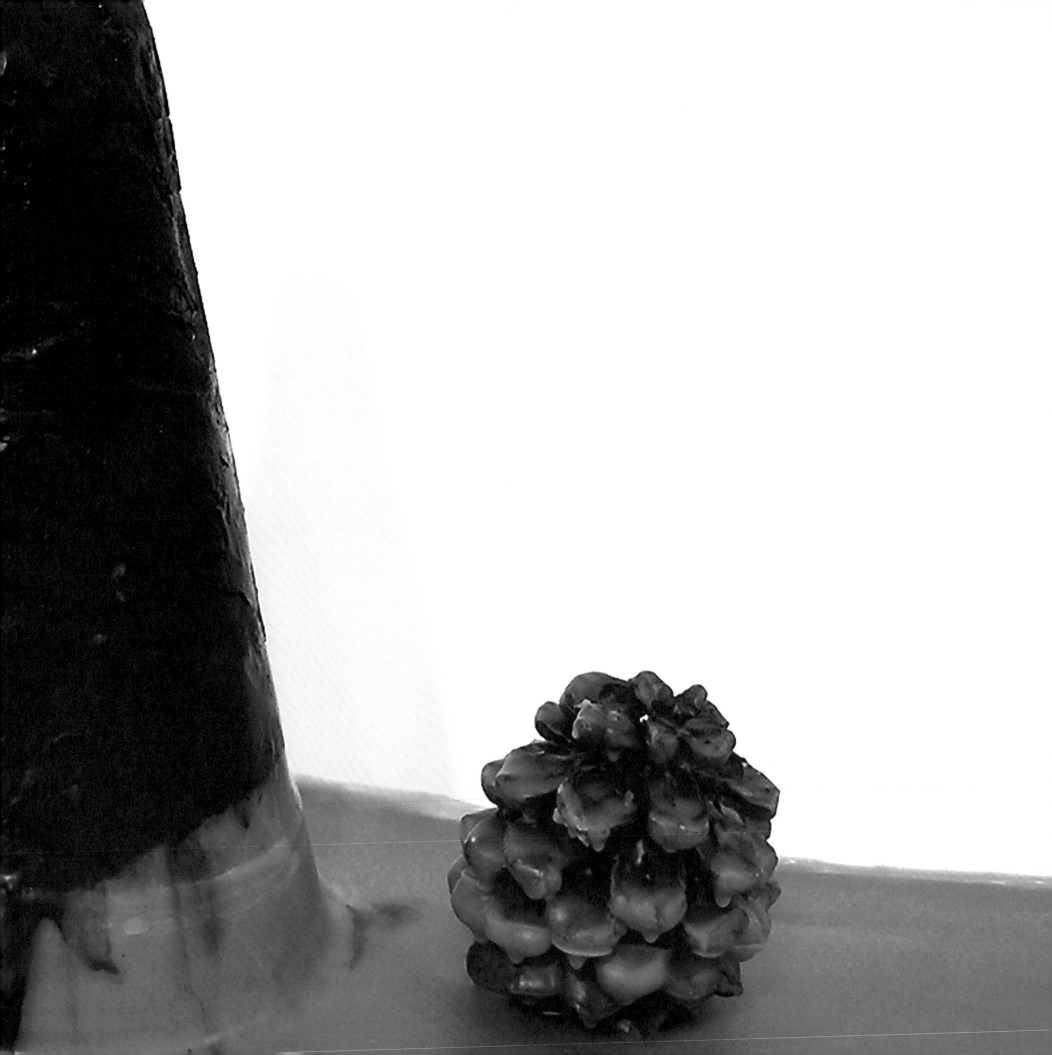

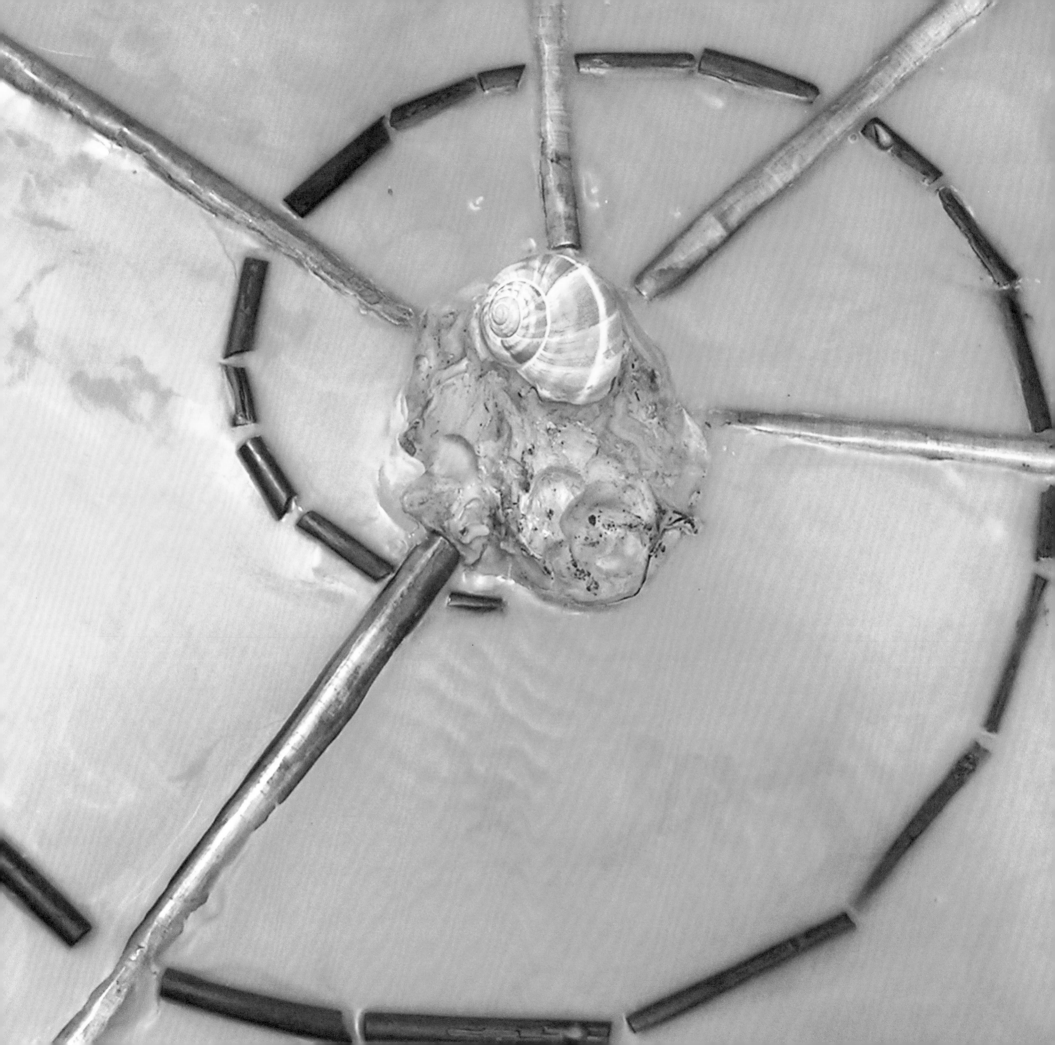

VII

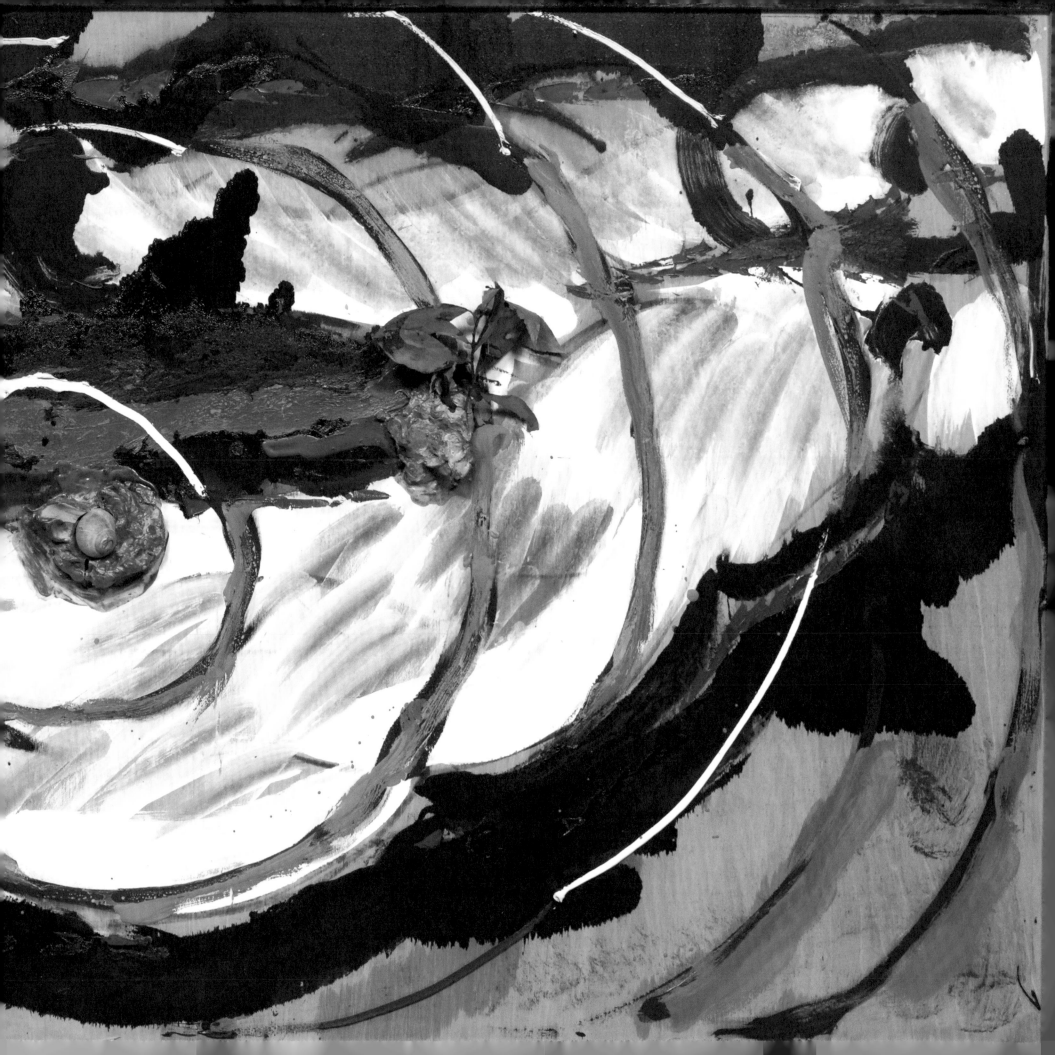

# Works in the exhibition

I
**Senza titolo (Untitled),** 1971
neon tubes with wires and transformer
142 x 80 inches (360 x 203.2 cm)

II
**Pianissimo (Very slowly, very softly),** 1984
beeswax, pine cone, Plexiglas, steel and aluminum
102 x 31 1/2 x 23 1/2 inches (259 x 80 x 60 cm)

III
**Tavola a spirale (Spiral table),** 1982
aluminum, glass, fruit, vegetables, branches, and beeswax
216 inches diameter (549 cm diameter)

IV
**Noi giriamo intorno alle case o le case girano intorno a noi? (Do we turn around the houses, or do the houses turn around us?)** 1982
charcoal and spray paint on vellum, bamboo and clay
138 x 171 x 131 inches (351 x 434 x 333 cm) overall

V
**Quattro tavole in forma di foglie di magnolia (Four tables in the shape of magnolia leaves),** 1985
beeswax and mixed media on 16 welded steel tables
29 inches x 65 feet 3 inches x 60 inches (73.7 x 1981 x 152.4 cm)

VI
**Senza titolo (Untitled),** 1985
beeswax and mixed media on a welded steel table
47 1/2 x 96 3/4 x 46 1/8 inches (120.7 x 245.8 x 117.2 cm)

VII
**Senza titolo (Untitled),** 1982
oil and water-based paint with clay, snail shell and leaves on wood
34 5/8 x 66 7/8 inches (88 x 170 cm)

# Biography
Marcella Beccaria

Born in Milan on January 1, 1925, Mario Merz grew up in Turin, in a family of Swiss origin. During World War II he left the medical school and joined the anti-fascist movement "Giustizia e Libertà" (Justice and Freedom). In 1945 he was arrested while leafleting and spent a year in Turin's prison. During his detention he executed numerous experimental drawings, made without ever removing the pencil point from the paper.

He had his first solo exhibition in 1954, at the Galleria La Bussola in Turin. He showed drawings and paintings whose subject matter refer to the organic universe and from which there emerges an awareness of "art informel" and the language of American Abstract Expressionism. He moved to Switzerland where he married Marisa in 1959, an artist who would become his inseparable companion, and in August 1960 their daughter Beatrice was born. Before returning to Turin, the couple went to Pisa where Merz created a series of "jutting forms", volumetric works seen as a possible fusion of the expressive means of painting and sculpture. He participated in group shows in Italy and abroad, including the ones organized by the Società Promotrice delle Belle Arti in Turin.

Beginning in the mid-1960s his desire to work with the idea of the transmission of energy from the organic to the inorganic led him to create works where neon pierces objects of everyday use, such as an umbrella, a glass, a bone or his own raincoat. In Turin he met the critic Germano Celant, who coined the definition "Arte Povera" and included him among the proponents of the new language. He participated in the early exhibitions of the group.

Around 1968, with the adoption of the form of the igloo, Merz definitively broke away from the two-dimensional wall plane. The first igloos were shown at the Deposito d'Arte Presente in Turin. Over the years, he produced numerous igloos, using a wide variety of materials and always developing new relations with the context.

Since 1970 he used the Fibonacci series, the numerical system wherein he saw a system representing processes of growth of the organic world. In 1973 he spent a year as artist in residence at the Berliner Künstlerprogramm. Here he focused on the theme of the table, fundamental element for the construction of a possible "Fibonacci House." *Live in Your Head: When Attitudes Become Form* (Kunsthalle Bern, 1969), *Op losse schroeven: situaties en cryptostructuren* (Stedelijk Museum Amsterdam, 1969), Tokyo Biennial (1970), *Processi di pensiero visualizzati: Junge italienische Avantgarde* (Kunstmuseum Luzern, 1970), Documenta 5, Kassel (1972), and Venice Biennale (1972), presented his work on the occasion of major group exhibitions. His first solo exhibition in the United States was held at the Walker Art Center in Minneapolis (1972). During the second half of the 1970s Merz began to develop a renewed interest in the pictorial practice and created a series of works where the igloo, bundles of sticks, neon numbers, tables, and vegetables also include packets of newspapers. His first solo exhibition in a European museum was held at the Kunsthalle, Basel and was followed by a show at the Institute of Contemporary Art, London (1975). He participated in the Venice Biennale in 1976 and 1978.

During the 1980s Merz's pictorial repertory became enriched with images of primitive, "terrible," and nocturnal animals. Major retrospective exhibitions of his work were presented at Museum Folkwang, Essen, Stedelijk van Abbemuseum, Eindhoven (1979), Whitechapel, London (1980), ARC-Musée d'Art Moderne de la Ville, Paris (1981), Kunsthalle, Basel (1981), Moderna Museet, Stockholm, Palazzo dei Congressi, San Marino (1983), and Kunsthaus, Zurich (1985). He participated in numerous group shows, including the Sydney Biennial (1979), Documenta 7 (1982), and the Venice Biennale (1986). In 1981 he was awarded the Arnold Bode prize in Kassel in 1983 he received in Vienna the Oskar Kokoschka prize and in 1989 the Kaiserring, Goslar. His writings were published in *Voglio fare subito unlibro (1985,* English edition *I Want to Write a Book Right Now,* 1989), an anthology edited by Beatrice Merz.

Merz created numerous installations in outdoor spaces in Turin, Paris, Geneva, Sonsbeck, and Münster and largescale works at the Museo di Capodimonte, Naples, the capc Musee d'art contemporain, Bordeaux, and at the Chapelle Saint-louis de la Salpêtrière, Paris (all in 1987). International recognition includes solo exhibitions at the Guggenheim Museum, New York (1989), Castello di Rivoli Museum of Contemporary Art, Centro per l'Arte Contemporanea Luigi Pecci, Prato (both in 1990), and Galleria Civica d'Arte Contemporanea, Trento (1995). He also continued to receive invitations to create installations for public spaces, including the Zurich railroad station, and the Strasbourg tramway. Major exhibitions of the Nineties included Documenta IX, Kassel (1992) and the Venice Biennale (1997). On the occasion of new solo exhibitions, such as one at the Fundação de Serralves, Porto (1999), Merz developed the theme of the "Fibonacci House." Also the practice of drawing became the focus of a series of large-scale installations. He exhibited at the Carre d'Art – Musee d'art contemporain, Nimes (2000), and he showed his work for the first time in Latin America, at the Fundaciõn Proa, Buenos Aires (2002), then travelling to different cities of Brazil. He participated in *Zero to Infinity: Arte Povera 1962-1972* (2001), the first survey show of Arte Povera in the United Kingdom, organized by the Tate Modern, London and by the Walker Art Center, Minneapolis. November 6, 2002 marked the opening of *Igloo Fontana (Igloo Fountain),* a permanent installation for the rail link for the city of Turin. Merz's numerous honors included the *Laurea honoris causa* from DAMS in Bologna (2001) and the *Praemium Imperiale* from the Japan Art Association (2003).

Mario Merz died on November 9, 2003 in Milan.

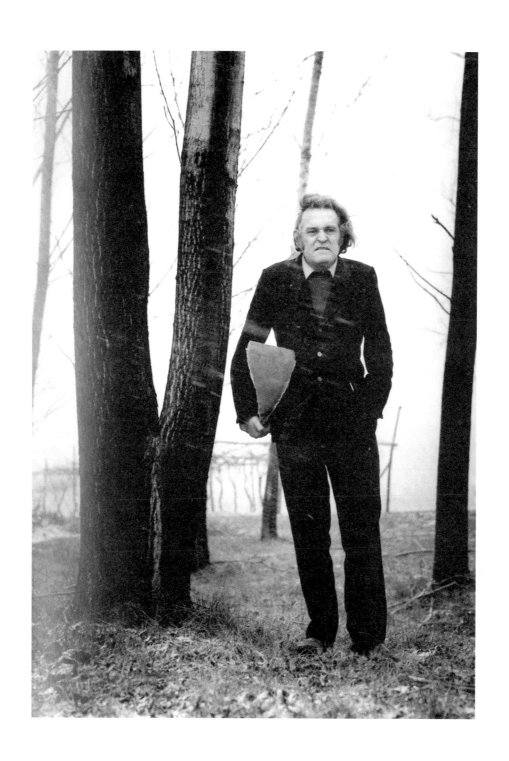

**Mario Merz**

The Magnolia Table

This catalogue is published on the occasion of the exhibition "Mario Merz: The Magnolia Table", presented at Sperone Westwater, New York, 2 November through 22 December 2007.

The exhibition was curated by Gian Enzo Sperone.

Design: Gian Enzo Sperone and Michael Short

Photography: Tom Powel
             Michael Short

Printed in Montreal, Canada by Transcontinental Litho Acme.

Published by Sperone Westwater, 415 West 13 Street, New York, NY 10014

ISBN 978-0-9799458-1-6

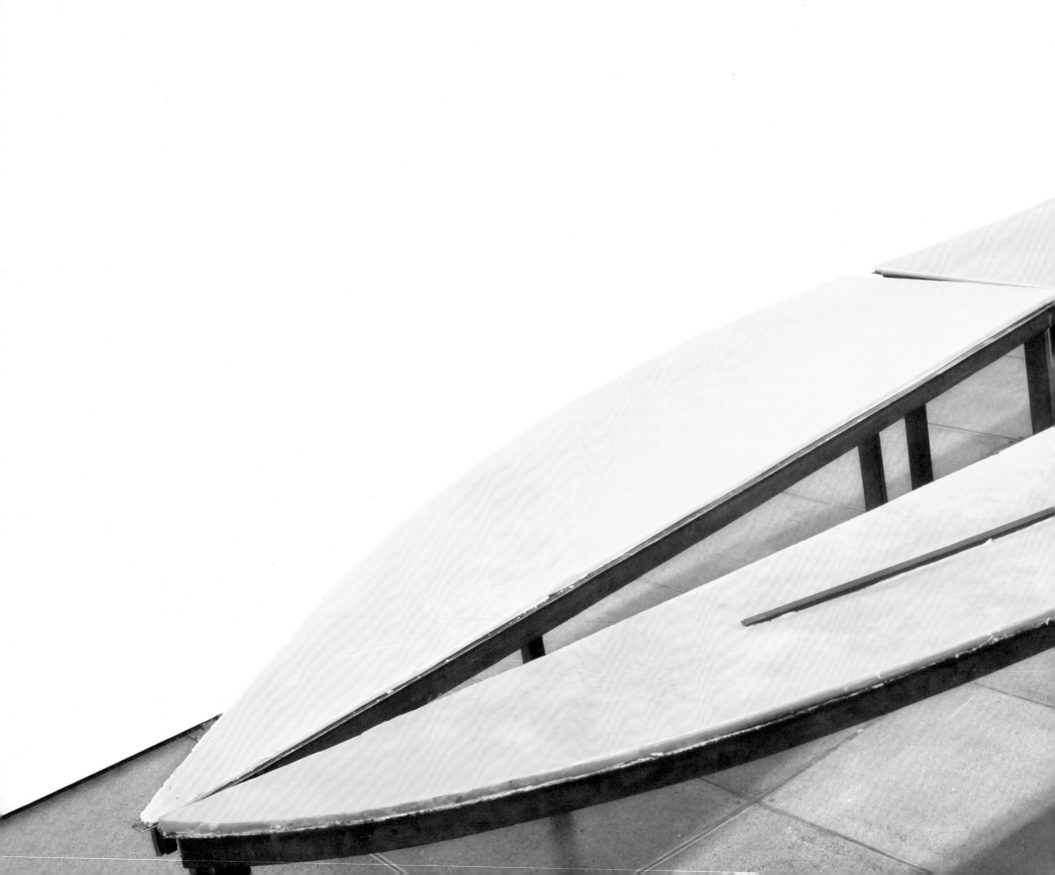